OTHER BOOKS BY ELAINE LANDAU

Terrorism: America's Growing Threat
Chemical and Biological Warfare
Weight: A Teenage Concern

Lyme Disease

RABIES

ELAINE LANDAU

LODESTAR BOOKS

Dutton ▪ New York

Library of Congress Cataloging-in-Publication Data
Landau, Elaine.
 Rabies / Elaine Landau.
 p. cm.
 Includes bibliographical references and index.
 Summary: Discusses rabies and its effects, how it is spread, how to protect animals and humans, and scientific advances in its control.
 ISBN 0-525-67403-9
 1. Rabies—Juvenile literature. [1. Rabies.] I. Title.
RC148.L33 1993
616.9′53—dc20 92-26117
 CIP
 AC

Published in the United States by Lodestar Books,
an affiliate of Dutton Children's Books,
a division of Penguin Books USA Inc.,
375 Hudson Street, New York, New York 10014

Published simultaneously in Canada
by McClelland & Stewart, Toronto

Editor: Virginia Buckley Designer: Richard Granald

Printed in Hong Kong First Edition
10 9 8 7 6 5 4 3 2 1

ACKNOWLEDGMENTS

*I am indebted to the informative staff of the
Sussex County Department of Public Health and
Safety in Frankford Township, New Jersey,
for providing vital data on this important topic.
My special thanks also go to Colin T. Campbell,
D.V.M., public health veterinarian,
New Jersey Department of Health,
for his invaluable assistance in ensuring the
manuscript's accuracy.*

CONTENTS

RABIES

1

A RABIES ALERT

An eight-year-old girl was playing in her family's driveway on a crisp autumn day in the quiet New Jersey town of Sparta. She didn't see the small red fox approach from the surrounding wooded area. Not until she heard the animal's long, low growl did she look up, but by then it was too late. A moment later, the fox sprang forward and bit her leg.

Screaming, she ran toward the front door of her home. But the animal pursued her, tearing at her arm with its teeth. The fox retreated only after the child was safely inside and her mother had slammed the door on the animal.

Instead of returning to the woods, the fox wandered farther down the street. There it attacked an eleven-year-old boy. The boy wrestled the fox to the ground,

1

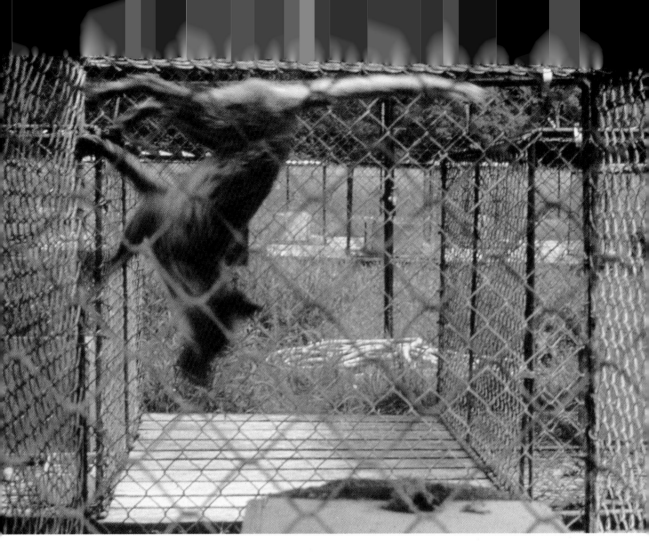

This rabid fox is wildly charging up and down the side of its cage, attempting to escape. (PHOTO BY GEORGE W. BERAN)

but the fox would not release its hold. Someone called the police, and very shortly, Officer Susan Jespersen arrived on the scene. The policewoman repeatedly struck the fox with her nightstick until it was dead.

A laboratory examination of the fox's head revealed that the animal had been rabid. As a result, the eight-

year-old girl and eleven-year-old boy were treated for rabies. Five other neighborhood children who might have come in contact with the fox began treatment as well. The rabid animal attack was not the small town's first such incident. Only three months earlier, a rabid raccoon had attacked a five-year-old girl playing in her backyard.

Nearly a thousand miles away in Okaloosa County, Florida, a raccoon kept as a pet became a neighborhood favorite. The friendly animal wore a bright-red collar and begged nearly everyone for food. The local children loved the cute, entertaining creature and went out of their way to feed and pet it.

After living in a backyard for several months, however, the raccoon disappeared. Some thought it had gone back to live in the woods, but before long the animal returned. Delighted to see it again, the town's children and adults warmly welcomed their wilderness friend home.

Unfortunately, while it was in the woods, the animal had contracted rabies. The raccoon didn't show any immediate symptoms of the disease, but soon its appearance and behavior changed. And when the once good-natured pet attacked several people, the community panicked.

Almost one hundred and fifty people had come in contact with the raccoon and, therefore, might have

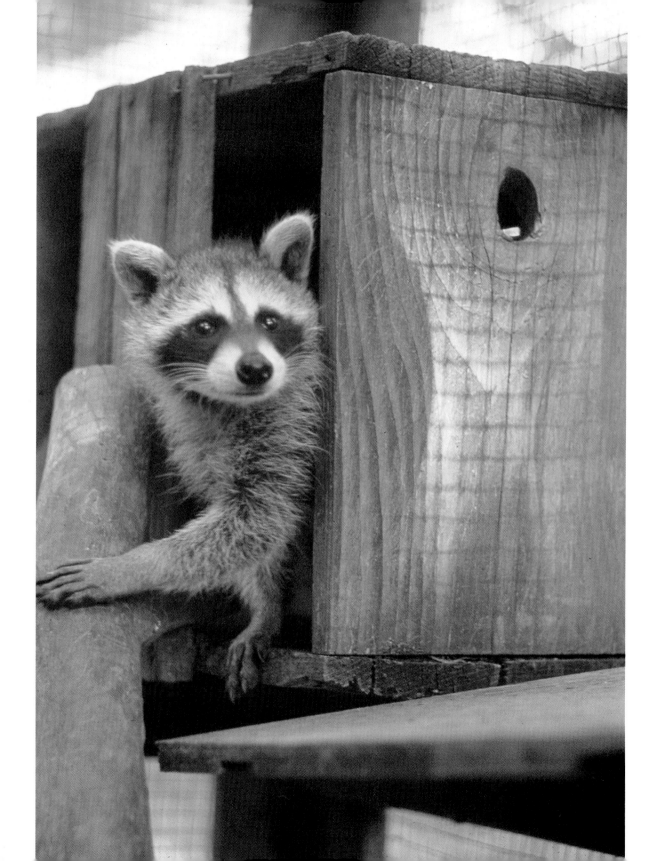

been exposed to the disease. Health department personnel and local doctors and nurses worked around the clock to identify anyone who might have been at risk. Eventually, over one hundred people were given shots to prevent the disease from infecting them, at a cost of almost twenty-two thousand dollars.

Rabid animals capable of transmitting the disease aren't always aggressive. When a rabid skunk entered an elementary school playground in Newton, New Jersey, it did not attack anyone. Instead, the animal seemed sleepy, and as it wobbled about, some of the students claimed that it looked drunk. Thinking that it might be injured, the children rushed over to help the animal. Without realizing it, they were exposing themselves to rabies.

Deer are generally not common carriers of the disease. Nevertheless, archers hunting deer in Fulton County, Pennsylvania, recently killed a rabid animal. Since the incident occurred at the start of the archery season, the Pennsylvania Department of Health sent out numerous calls to warn hunters about the danger of rabid deer in the woods. Hunters were warned to be aware of unusual behavior in animals. They were also advised to cover their hands, nose, and mouth while

Small wild animals often seem cute and playful, but never make a pet of one like the raccoon in this pet house.
(PHOTO BY GEORGE W. BERAN)

5

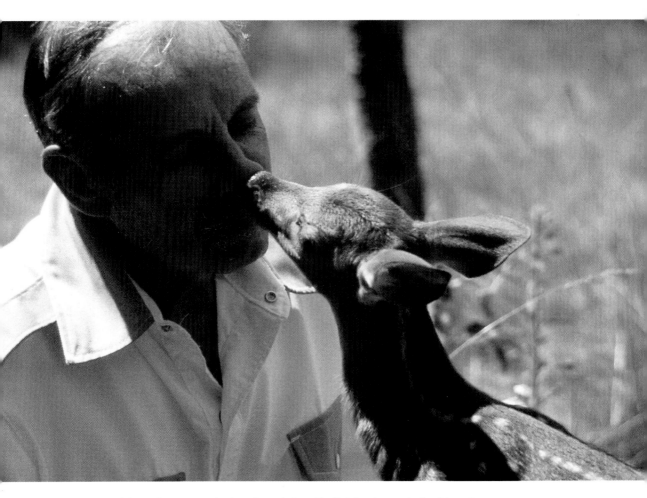

New Jersey veterinarian John E. Bridenbaugh befriends a young deer. Wild orphan babies should be rescued only by trained professionals. (JOHN E. BRIDENBAUGH)

skinning deer. Because of rabid deer slaying, several meat processing plants in the area refused to accept venison.

Few people in the United States have recently died of rabies. Yet during the 1980s, doctors in Boston, Massachusetts, and Houston, Texas, struggled to identify and curb the illness in a number of patients. In both cities, victims were thought to have contracted the disease while out of the country, after having been bitten by rabid animals. But shortly thereafter, a twelve-year-old boy from Williamsport, Pennsylvania, died of rabies. No one knew how he had contracted the disease. He had never left the United States or even been away from home. At the same time, health departments in various regions around the country began to receive more reports of rabid animals. Clearly, the public needed to know more about the disease.

2

WHAT IS RABIES?

Rabies is a deadly disease that affects the brain and spinal cord. It is transmitted through the saliva of an infected animal, usually by a bite. But it can be contracted in other ways as well. Rabies can be transmitted to people or other animals when saliva from an infected animal comes in contact with a cut, scrape, or other break in their skin. Any warm-blooded animal can contract rabies.

Rabies can also be contracted by breathing the air in caves that house large numbers of rabid bats. In such instances, the cave's floor is usually filled with infected bat droppings.

Once inside the body, the rabies virus multiplies. It travels from its entry point to the spinal cord before reaching the brain. There are two forms of rabies. In

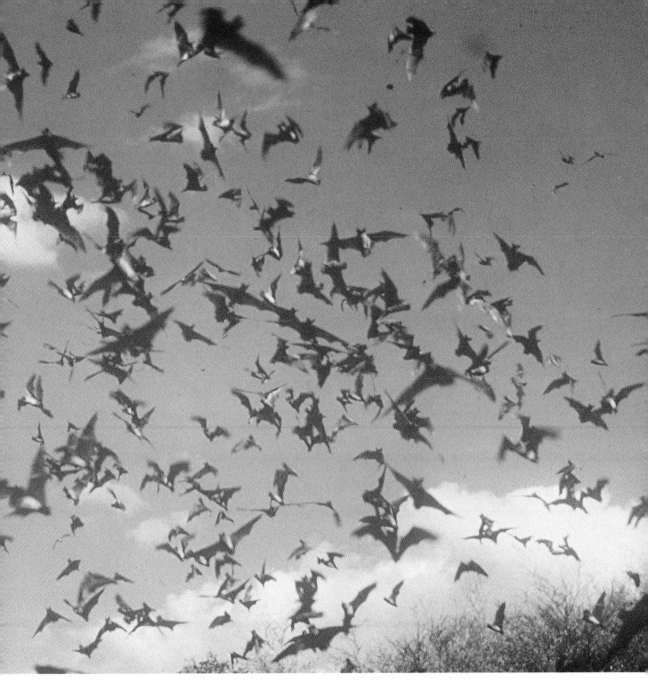

Bats are generally active at night. Avoid any bat out during daylight—these are usually rabid. Incidents involving rabid bats have been reported in nearly every state.
(CENTERS FOR DISEASE CONTROL)

the first, or furious, type, which largely affects the brain, the infected animal appears excited and aggressive. The word *rabies* means fury or rage in Latin. It describes the way these animals attack any person, animal, or object in their path.

In the second form—paralytic, or dumb, rabies—the infected animal does not display these symptoms. This form of rabies mainly affects the spinal cord, thus paralyzing the animal.

The telltale signs of rabies may not always be evident early in the disease. A wild animal sitting in a yard for an extended period, running in circles, or flopping about may be suspect. Other symptoms of rabies in animals include loss of appetite, extreme irritability, making funny-sounding cries or barks, restlessness, jumping at noises, difficulty swallowing, excessive salivation (drooling), tremors, convulsions, or aggressiveness. An animal infected with furious rabies may seem unusually tame before aggressive symptoms appear.

In the beginning phase of dumb rabies, the animal may seem to be choking. Anyone who comes to its aid is at risk of contracting the disease.

It is important to remember that an infected animal can transmit, or "shed," the rabies virus even before symptoms appear. An animal does not have to drool or stumble as it walks to be capable of spreading the

disease. People have contracted rabies from perfectly healthy-looking animals.

Rabies is a serious disease. Its incubation period—the time between infection and the symptoms' appearance—in humans ranges from a few weeks to as long as a year in unusual cases. The likelihood of contracting the disease from an infected animal, as well as the incubation time, varies from case to case.

A rabid dog on a leash. (ROBERT GORDON)

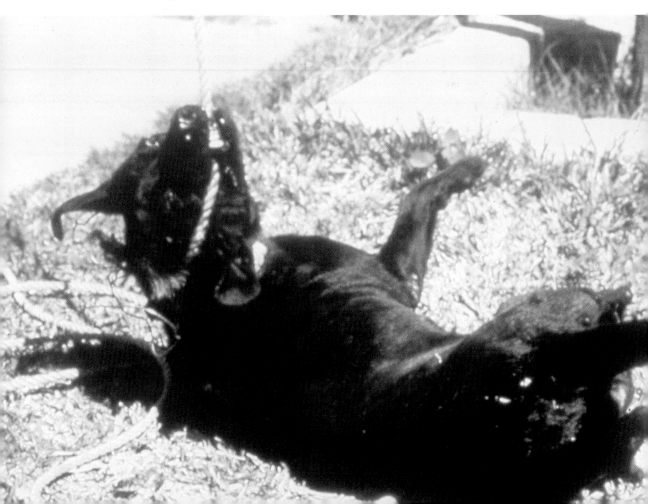

Generally, the incubation period depends both on the location of the bite and the dose of the virus received. The farther away from the brain that a person is bitten, the longer the incubation period and the lower the risk of contracting the disease.

Infected individuals who don't receive treatment will experience a string of worsening symptoms. Even after the animal bite heals, there may be itching, burning, or a cold sensation near the site of the wound. Early rabies symptoms also include fever, headache, and a sore throat. The victim often feels as if a bad cold or flu has set in.

Before long, the rabies sufferer grows nervous, restless, and unusually sensitive to light and sound. He or she may become extremely excited and have hallucinations and convulsions. Or the sufferer may experience difficulty swallowing and develop a fear of water known as hydrophobia. Following these symptoms, paralysis sets in, or the person may slip into a coma. Cardiac or respiratory arrest resulting in death frequently occurs within a week. However, all this can be avoided if the individual is promptly treated.

In ancient times, the disease was often misunderstood. The early Greeks incorrectly believed that a

This young boy was bitten on the face by a rabid dog.
(PHOTO BY GEORGE W. BERAN)

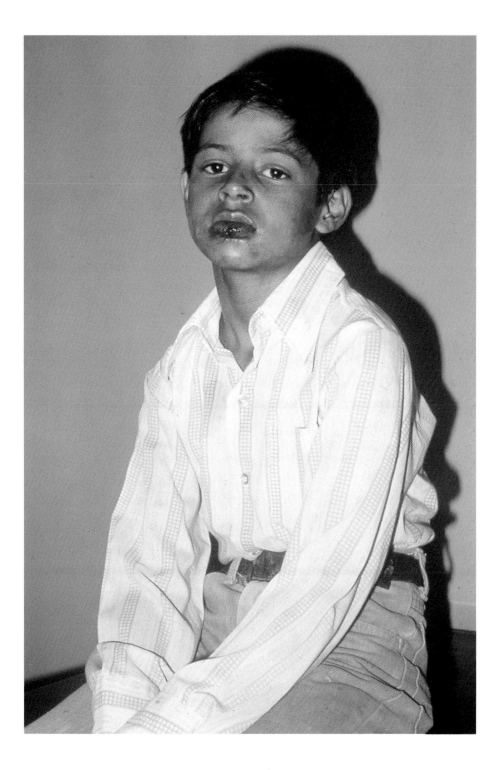

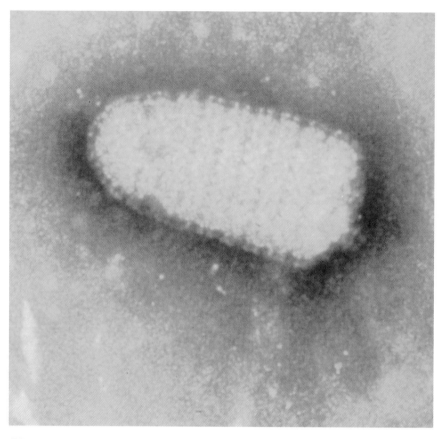

The bullet-shaped rabies virus pictured here can infect any warm-blooded animal. (ROBERT GORDON)

"mad" dog could transmit rabies to other animals but not to humans. Later on, the Romans realized that rabies affected people, but they mistakenly thought it could be cured by holding the ill person's head under water. As a result, rabies victims often died by drowning, not from the disease itself.

In the sixteenth century, the Italian physician Girolamo Fracastoro discovered that rabies was a disease fatal to humans as well as to animals. He called the illness "the incurable wound." Because he was a well-respected doctor and scientist of his day, his views were widely accepted.

Finally, in 1881, the well-known scientist Louis Pasteur began searching for a way to cure rabies. He spent

A print showing people shielding themselves from a rabid dog in Old England reminds us how long rabies has been a problem.
(NATIONAL LIBRARY OF MEDICINE)

countless hours in his laboratory experimenting with different remedies. Then one afternoon in 1885 Pasteur was forced to put his work into action. The parents of a young boy who had been bitten by a rabid dog came to Pasteur's home begging him to save their son.

At first, the scientist hesitated to try his untested vaccine on a human being. But after the boy's mother and father pleaded with him, Pasteur agreed. He treated the boy, Joseph Meister, for several weeks. Happily, the vaccine was successful, and young Meister did not contract the disease.

Since then, scientists have developed a number of rabies vaccines. Some of the cruder treatments included extremely unpleasant side effects. One rabies vaccine that was commonly used could cause permanent damage to the nervous system. By 1957, a safer vaccine existed, but it was administered in a series of twenty-three painful injections through the abdominal wall. Fortunately, an effective and painless vaccine is available today. It is given through five injections taken over a four-week period.

Every year over thirty thousand people in the United States are immunized against rabies, usually after coming in contact with a rabid animal. People who regularly handle animals, such as veterinarians, veterinary technicians, and animal-control officers, can be immunized before they are actually exposed to ra-

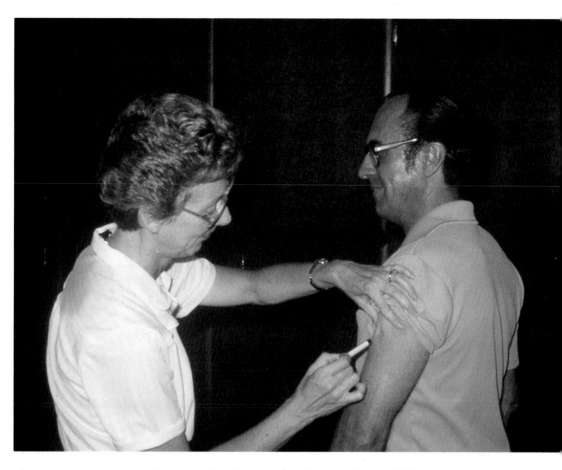

A man receives a rabies vaccination. In the United States 300 million dollars are spent each year on rabies control.
(PHOTO BY GEORGE W. BERAN)

bies. If they are later exposed to rabies, they receive only two booster doses instead of the usual five-dose treatment. Prompt treatment after exposure is crucial because once a patient develops symptoms of rabies, there is no cure, and the patient will die shortly afterward. If someone is bitten by or exposed to saliva

17

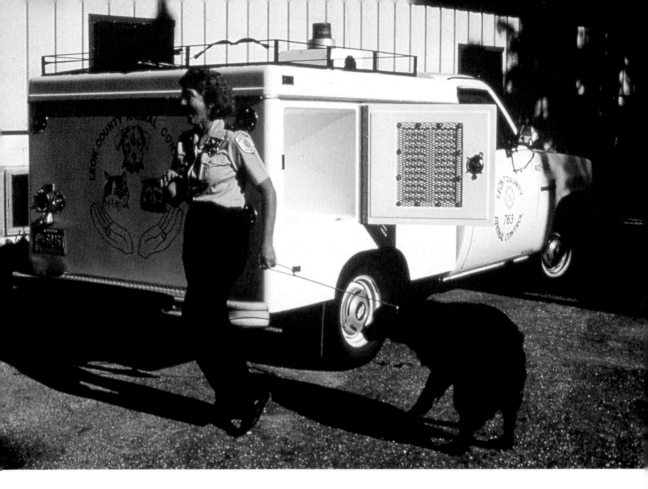

An animal-control officer brings in a stray dog for observation.
(STATE OF FLORIDA DEPARTMENT OF HEALTH AND REHABILITATIVE SERVICES)

from an animal suspected to be rabid, and the animal is not available for testing, the person should consult a doctor immediately to determine whether rabies treatment is needed.

Doctors consider the following factors when determining whether to treat a patient for rabies:

■ Was the person's skin broken? Or did the mucous membranes come in direct contact with the virus?

- Did the animal appear sick or act strangely?
- Was the dog or cat that bit the person vaccinated for rabies?
- Can the animal be located for observation? If so, the animal is monitored for ten days. If it does not develop symptoms of rabies within that period, treatment is not necessary.
- If the person was bitten by a wild animal that can't be located, is the animal a species in which rabies is likely to occur?

Which dog is rabid? If you said the snarling one, you are wrong! This beagle is a good example of how a seemingly normal dog can actually have rabies. (SNARLING DOG—RHONE MERIEUX, INC., BEAGLE—CENTERS FOR DISEASE CONTROL)

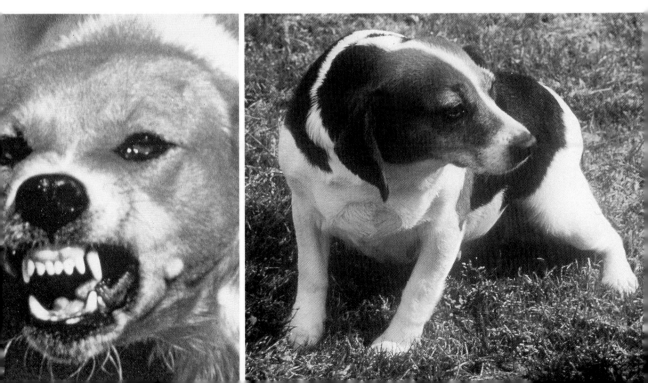

■ Did the animal bite without cause? Rabid animals are far more likely than healthy animals to bite for no reason.

Health department officials stress that any bite or deep scratch from an unfamiliar animal should be taken seriously. But the public is not always easily convinced of the need to take immediate action.

3

RABIES ON THE RISE

Rabies has existed for as long as anyone can remember. Until the late 1940s, most humans in the United States contracted rabies from pets, such as dogs and cats, or domestic animals like cattle or horses. After World War II, however, the number of cases sharply declined. This may have been the result of strict licensing and vaccination laws for dogs and the careful control of stray animals in most areas.

Recently, there has been a dramatic increase in rabies among wild animals. Those most affected by the disease include skunks, raccoons, bats, foxes, and bobcats. Since the mid-1980s, dogs have accounted for only 2 or 3 percent of the total rabies cases among animals. Eighty-two percent of all rabies cases in the United States involve skunks, raccoons, and bats.

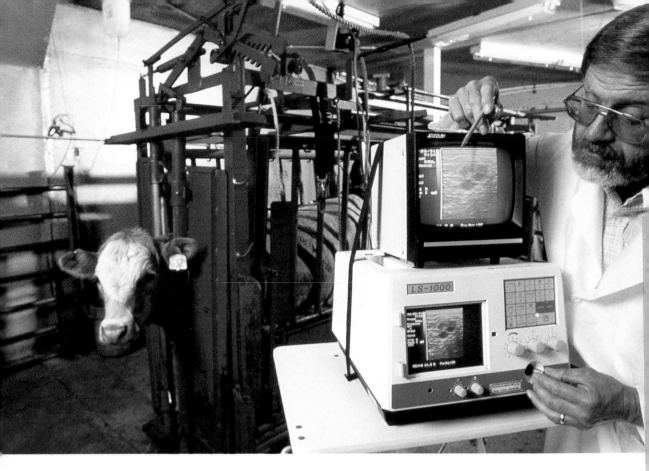

Modern equipment is used to view a pregnant cow's unborn calf. Following its birth, the calf will be vaccinated for rabies, as its mother was. (AGRICULTURAL RESEARCH SERVICE, U.S. DEPARTMENT OF AGRICULTURE)

The trouble began in 1977 when 3,500 Florida raccoons were brought to West Virginia for sportsmen to hunt. Although it wasn't known at the time, some of these animals were rabid. The infected raccoons soon transmitted the disease to other wildlife species. As the months passed, the disease crept steadily northward.

Before long, infected raccoons, skunks, bats, deer, cattle, sheep, and cats were turning up in New Jersey,

New York, and Connecticut. The disease is now spreading at the rate of approximately fifty miles a year and is reaching farther into New England. Rabies in wild animals is especially difficult to control because the animals tend to roam and cannot be isolated.

In other parts of the country, however, raccoons are not the primary carriers of the disease. California has experienced an increase in skunk rabies. Cases of fox

These Florida children are feeding raccoons—a dangerous pastime. Rabid Florida raccoons transported to West Virginia helped to spread the disease along the east coast. (STATE OF FLORIDA DEPARTMENT OF HEALTH AND REHABILITATIVE SERVICES)

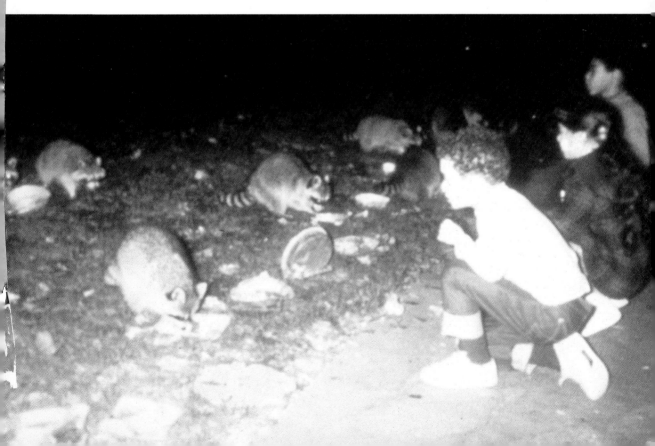

rabies have occurred as far east as New York and as far west as Texas. In Texas there has also been a rise of the disease in coyotes. Washington and Oregon report five to ten incidents of rabid bats each year. Bat rabies is becoming particularly widespread. The disease has been found in most of the nearly forty species of bats in the country. But no matter which animals transmit the disease, rabies is undeniably on the rise in much of the United States.

The dry desert areas of the nation generally have fewer rabies outbreaks. Rodents, such as squirrels, rabbits, and rats, that inhabit these regions are less susceptible to the disease. Because of its isolated geographical location and strict animal importation regulations, Hawaii is the only state that has remained rabies free.

Health authorities in many places are particularly concerned that the disease will spread to dogs, cats, and other domestic animals. If unvaccinated pets become infected, the illness could be readily transmitted to their owners. In the early 1980s, rabid cats outnumbered rabid dogs for the first time in the United States. This may be because cats are night hunters,

A ranger brings in an injured coyote. Texas is now experiencing a rabies outbreak among coyotes. (U.S. FISH AND WILDLIFE SERVICE, PHOTO BY PEDRO RAMIREZ)

and, therefore, are more likely to come in contact with rabid animals, such as infected raccoons, that are also active at night. The lack of vaccination requirements and leash laws for cats in numerous states adds to the problem.

All the while that rabies has been increasing in parts of the United States, the situation has grown even worse in some other countries. Portions of Asia, Africa, and South and Central America frequently report cases of human rabies. The World Health Organization states that rabies is a problem in about one hundred countries and territories throughout the world. In many of these regions, dogs are the most common carriers of the disease. Packs of unvaccinated strays frequently roam city streets, posing a danger to both residents and tourists.

Health officials everywhere agree that rabies is difficult to control. For years, inhabitants in the province of Ontario, Canada, have tried to deal with a large population of rabid wild animals. But until recently, the nearby Canadian island of Newfoundland was one of the few rabies-free areas in North America. Its last-known case of rabies occurred in 1955.

Area veterinarians rarely vaccinated local animals for the disease, since a rabies outbreak was unlikely. The icy waters surrounding the island largely pre-

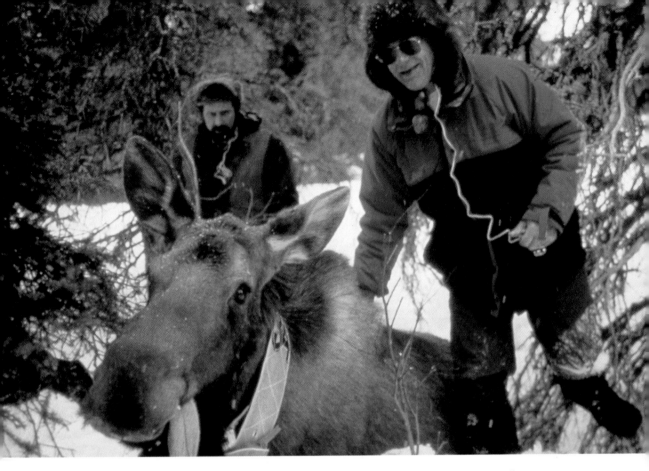

Rabies strikes in northern areas such as Newfoundland as well as in the tropics. This moose is having a radio collar put on for tracking purposes. Such information helps researchers learn more about how rabies spreads to different regions. (U.S. FISH AND WILDLIFE SERVICE, PHOTO BY MARK LISAC)

vented rabid animals from migrating to the region. Local health officials also did not permit pets to be brought there unless their owners produced the animals' rabies vaccination certificates.

Then a dead fox was found with its teeth locked around an iron bar at an old saw mill. An examination confirmed that it was rabid. Authorities believe

that the fox arrived on the island during the winter, after making its way from the Arctic on ice floes. Since that time, a second rabid fox has been discovered in Newfoundland.

Fearing spread of the disease, health department and local veterinarians have begun vaccinating pets in towns and villages throughout the region. The island's animal population will certainly benefit from this safety measure. However, as Hugh Whitney, the local animal health director, told the press, ". . . [Now] we are trying to protect the humans."

4

PROTECTING YOURSELF

Whether you live in an area where rabies is on the rise, or just occasionally come across an animal acting strangely, there are measures you can take to protect both yourself and your pets. Although vaccines exist for domestic animals, as yet none are approved for wild animals. Therefore, avoid direct contact and do not adopt them as pets.

A spokesperson for a health department's Rabies Control Program in New Jersey described the following incident:

An elderly woman living near a wooded spot started leaving out food for a raccoon. She named the animal, and while it didn't live on her property, the woman thought of it as her pet. She looked forward to the raccoon's visits and eagerly awaited its approach each day.

The man living next door was a hunter, who owned several rifles. One day, he noticed the raccoon entering his neighbor's yard, headed for her back porch. The man didn't know that the woman regularly fed the raccoon there. But he was aware of a rabies alert in the area. He also knew that raccoons frequently carry the disease and that rabid animals often readily approach humans. Thinking that the raccoon was probably rabid, he got out his gun and shot it. While hoping to protect his neighbor, he actually killed her pet.

The woman was horrified by the senseless death of the raccoon she'd cared for. When later tested, the animal was shown not to be rabid. That raccoon would still be alive today if the well-meaning woman hadn't tried to turn it into a pet. Wild animals have their place in nature and should never be substituted for a dog or cat.

Avoiding direct contact with wild animals is essential.

The following steps are crucial in preventing rabies:

■ If you have a pet cat or dog, be sure the animal is vaccinated for rabies. Many public health departments offer free rabies vaccination clinics for both dogs and cats. Contact your local public health department

A cat and two kittens rest near a feline vaccination schedule. To keep your cat safe and healthy, be sure it receives its rabies vaccination and other necessary shots. (ARTHUR BAEDER)

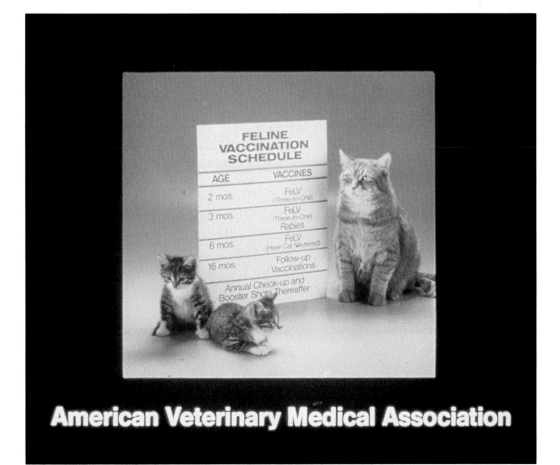

for more information about this service, or call your veterinarian.

■ Have your dog or cat licensed. Be aware of and observe the local animal-control regulations of your city or town.

■ If your dog or cat doesn't seem well, consult your veterinarian or animal clinic.

■ To protect your pets from stray or wild animals, do not allow them to run loose. Keep your cats indoors or in a fenced-in area. Walk your dog on a leash away from heavily wooded areas. Never leave a pet chained in a yard alone. If attacked by a rabid animal, it has no chance of escaping.

■ Report stray animals or animals acting sick or strangely to the proper authorities. This allows an animal-control officer to investigate a potentially dangerous situation. Nevertheless, it is important not to overreact. "We're encouraging caution, not panic," one state health official warned. "You've got to remember that we've had squirrels in our backyards forever. If you see a squirrel in the backyard during the day or a raccoon sleeping in a wooded area, that's not abnormal behavior. But when you see animals staggering, salivating, or expressing aggressive behavior, that's different. We're concerned about these animals, and want to be called about them."

■ Do not touch a wild animal even if it is dead or

injured. Try especially to avoid contact with raccoons, bats, skunks, foxes, and groundhogs.

■ Keep garbage cans tightly closed. This discourages wild animals from foraging for food in them. Home owners should cap their chimneys or place wire over the chimney top to prevent rabid animals from climbing into their homes.

■ If your pet is fighting with another animal, do not try to stop them yourself. Find a responsible adult to help you. The adult can separate animals by using a long pole, rake, or hose.

Rabies poses an even greater threat to people than to pets. Although their animals are usually already vaccinated for the disease, most people aren't.

If You Are Bitten by a Wild Animal . . .

■ Immediately wash the wound thoroughly with soap and water. Scrub the affected area well. Detergents help to kill the virus, while water flushes it away from the site of the bite. Allowing the wound to bleed also helps to cleanse it.

■ Seek medical attention. See your family doctor or go to the nearest hospital emergency room. It's important to secure proper treatment right away.

■ A responsible adult should try to confine and isolate

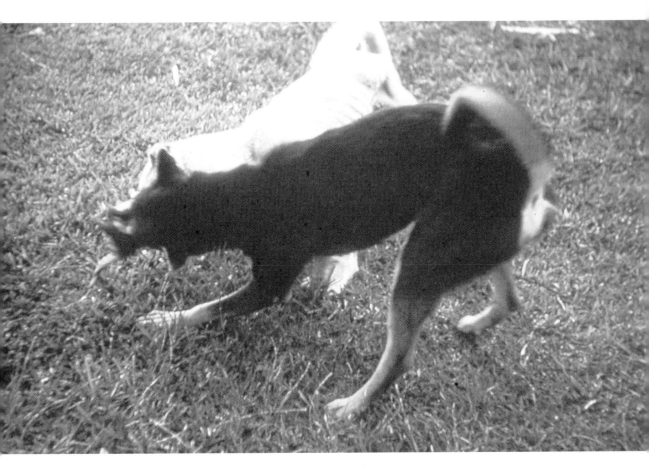

The rabid white dog is attacking another animal. If your pet is attacked, don't try to step in between them. You could be seriously injured. (PHOTO BY GEORGE W. BERAN)

the animal while being careful to prevent additional bites. Call your local animal-control officer or the police to remove the animal. A bat, raccoon, skunk, groundhog, or fox that has bitten a person should be destroyed. This procedure may be omitted only if the incident occurred in a rabies-free area and the animal

is known not to have the disease. Otherwise, the wild animal must be sacrificed, since blood tests are unreliable in identifying rabies. The only way to pinpoint the disease is to place a segment of the animal's brain under a microscope and check for the virus with a special test. If the animal is shown to be rabid, anyone bitten by it must be treated for rabies at once.

Notice the porcupine quills in the cheeks and jaws of this severed skunk head. The animal was probably rabid, since healthy skunks generally don't go after porcupines. (STATE OF NEW YORK DEPARTMENT OF HEALTH)

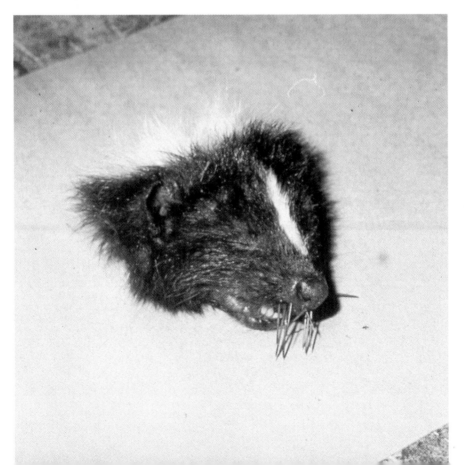

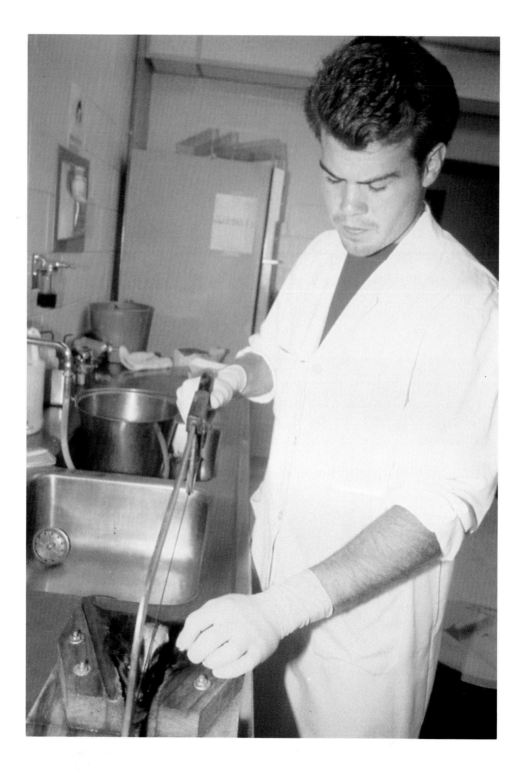

If You Are Bitten by a Pet Cat or Dog . . .

■ A healthy pet cat or dog that has bitten a human should be confined and observed for ten days. This is necessary even if the animal has already been vaccinated for rabies. Unfortunately, in very rare cases, the vaccine does not protect an animal from the disease. Any illness detected in the pet during this time must be evaluated by a veterinarian and reported to the local public health department.

■ If rabies symptoms develop, the animal should be humanely put to death and submitted for rabies test-

(Opposite) A researcher dissects the brain of a rabid cat. (Below) Following the dissection, pieces of the animal's brain are placed on a slide to be tested for rabies. (KANSAS STATE UNIVERSITY, PHOTOS BY DEBORAH J. BRIGGS)

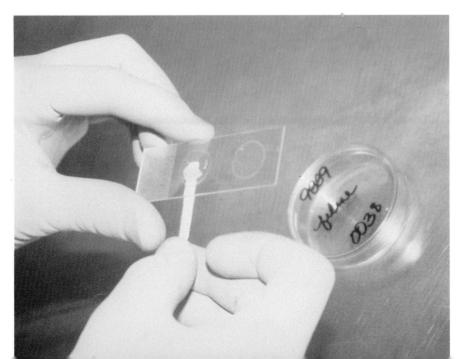

ing. If the animal is rabid, all bite victims must begin immediate treatment for the disease.

■ If you are bitten by a dog while vacationing out of the country, you should see a doctor at once. Be sure the physician is aware of when, where, and how the bite occurred. In the United States, most dogs are vaccinated for rabies, but this isn't always true elsewhere.

If Your Pet Is Bitten by a Rabid Animal . . .

Even if your pet has already been vaccinated, a veterinarian must give it a rabies booster shot. The veterinarian also has to report the bite to the local public health department. Following treatment, the pet must be confined at home for three months. It may only leave the premises on a leash to be walked.

An unvaccinated pet must either be destroyed or quarantined at home in an enclosed pen for six months. If the animal has not shown any sign of the disease after five months, it is vaccinated for rabies and released the following month.

5

THE FUTURE

Today scientists are actively working to curb the spread of rabies. Since the disease in the United States is largely spread by wild animals, health experts face an especially difficult task: Preventing these animals from traveling to new areas is nearly impossible.

Although urban Americans may think they won't come in contact with the disease, this isn't always true. Raccoons are well adapted to suburban areas and can be found living in close proximity to people. At times rabid animals have migrated from nearby wooded areas to city parks. In fact, in March 1992, New York City Health Department officials declared a rabies alert when rabid raccoons were found within city limits.

Researchers want to eliminate the disease in the wild before it reaches populated suburban and urban

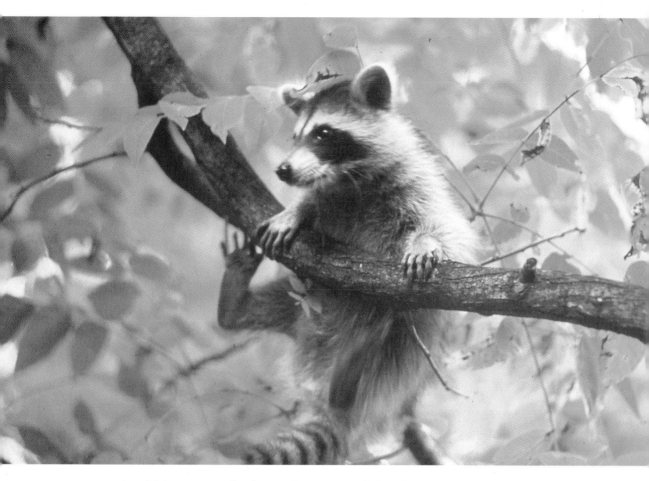

A rabid raccoon, in the early stages of the disease, is unable to hold its balance well. This animal is likely to spread the disease to other animals before dying. (PHOTO BY GEORGE W. BERAN)

regions. Until recently, wildlife managers often resorted to programs aimed at poisoning disease carriers in places where rabies was particularly widespread. But, unfortunately, while the poison killed a large number of rabid animals, many healthy ones perished as well. Some of the species that were poisoned weren't even likely to contract the disease.

Now scientists are developing a rabies vaccine for wild animals. Some of the early vaccines proved to be both dangerous and ineffective. During laboratory trials, many animals on whom the vaccines were tested became rabid.

Recently, researchers from the United States and France developed a new vaccine that appeared to be a vast improvement over the others.

The problem was to find a way to administer the vaccine to countless animals in the wild. The scientists determined that packaging the vaccine in tasty "sandwiches" and dropping them from airplanes over targeted areas might be effective.

To test this idea, over two thousand such sandwich bags—without the vaccine—were lowered onto state game lands in Pennsylvania. They contained varied mixtures of wild grapes, turkey gravy, shellfish oil, bananas, or feta cheese. The researchers hoped the animals would take the flavored bait.

In laboratory tests, captive raccoons had torn open the flavored pouches to eat a small sponge inside soaked with the vaccine. However, success in a laboratory setting does not always guarantee success in the wild. More research needs to be done to determine the safety, reliability, and cost of scattering the rabies vaccine over hundreds of square miles of wilderness.

The testing also raised other vital concerns. What

would be the long-term effects on animals that don't generally contract rabies if they took the vaccine as readily as disease carriers? To some extent, rabies serves as a form of animal-population control in certain areas. If the disease were wiped out and this natural balance upset, how would the environment be affected?

As scientists seek answers to these and other questions, research on the new rabies vaccine continues. Airplane drops of sandwich bags containing the actual vaccine have already been successful in various parts of the United States. Veterinarians, such as those from New York State College of Veterinary Medicine in Ithaca, have trapped raccoons in the wild and injected them with the vaccine. But even as the work progresses, new rabies outbreaks occur around the globe.

People in the far-off jungles of Peru now face the unchecked spread of rabies daily. Maria, an eight-year-old Peruvian girl, experienced its horror the night she was attacked by a vampire bat while asleep in her bed. After flying into her family's hut, the animal quietly approached the girl on foot and tore her flesh with its razor-sharp front teeth. The child's shrill screams awoke her father, who killed the bat with a club.

His young daughter's wounds quickly healed, but before long she began to experience high fevers and

painful headaches. By the time Maria saw a doctor, it was too late. The bat that bit the child had been rabid, and she died less than two weeks afterward. Unfortunately, Maria's story is not unusual. Over thirty other people from her village also died of rabies within months. Their fate underscores the vital need for further research to halt this worldwide disease.

After being ear tagged and vaccinated, this raccoon will be released at the site of capture in a raccoon rabies vaccination trial. (LARRY CARBONI)

GLOSSARY

coma a continuing state of unconsciousness caused by disease or injury

contract to become infected with a disease

convulsion an abnormal and violent body spasm

domestic animal a tame animal

foraging the act of seeking food

hallucination image of something that isn't there

hydrophobia an intense fear of water

immunized protected from a disease through the presence of antibodies in the blood. An antibody is a protein produced by the body that destroys foreign invaders, including viruses.

paralysis a condition in which a person or animal loses the ability to move

quarantined isolation of a person or animal thought to have an infectious disease for a fixed period of time

saliva a mixture of mucus and fluid released by glands in the cheeks and lower jaw

species a specific type of plant or animal

symptom a sign or condition indicating a disease

transmit to pass on from one organism to another

vaccine an altered virus used to protect a person or animal from a disease

venison the flesh of a wild animal, especially a deer, used for food

veterinarian an individual trained to treat animals medically
and surgically

warm-blooded having a stable and warm body temperature

FOR FURTHER READING

Berger, Gilda. *The Human Body.* New York: Doubleday, 1989.

Berger, Melvin. *Ouch! A Book About Cuts, Scratches, and Scrapes.* New York: Lodestar Books, 1991.

Breslow, Susan, and Blakemore, Sally. *I Really Want a Dog.* New York: Dutton, 1990.

Johnston, Ginny, and Cutchins, Judy. *Windows on Wildlife.* New York: Morrow, 1990.

Kudlinski, Kathleen V. *Animal Tracks and Trails.* New York: Franklin Watts, 1991.

Kuklin, Susan. *I'm Taking My Cat to the Vet.* New York: Bradbury Press, 1988.

Newfield, Marcia. *The Life of Louis Pasteur.* Frederick, Maryland: Twenty-First Century Books, 1991.

Pringle, Laurence. *Batman: Exploring the World of Bats.* New York: Charles Scribner's Sons, 1991.

Schwartz, David M. *The Hidden Life of the Forest.* New York: Crown, 1988.

Squire, Ann, Ph.D. *Understanding Man's Best Friend: Why Dogs Look and Act the Way They Do.* New York: Macmillan, 1991.

Staple, Michelle, and Gamlin, Linda. *The Random House Book of 1001 Questions and Answers About Animals.* New York: Random House, 1990.

INDEX

Page numbers in *italics* refer to illustrations.

ABOUT THE AUTHOR

Elaine Landau received a B.A. degree in English and journalism from New York University and a master's degree in library and information science from Pratt Institute. She has worked as a newspaper reporter, an editor, and a youth services librarian. But she believes that many of her most exciting, as well as rewarding, hours have been spent researching and writing over fifty books for young people. Her most recent book for Lodestar is *Terrorism: America's Growing Threat.*

Ms. Landau lives in Sparta, New Jersey.